landseandsky

Copyright © 2019 Rainer Neumann

All rights reserved. No part of this book may be reproduced in any form or by any means, electronic or mechanical, including photocopying, recording or by any information storage and retrieval system, without permission in writing from the publisher.

ISBN 978-1-387-78681-7

For printed works go to:
lulu.com/spotlight/rneumann

All other inquiries email:
onhighwayone@gmail.com

Friday night jazzz
at the Cafe Society

Poems Songs Images by
Rainer Neumann

Homage to Harpo

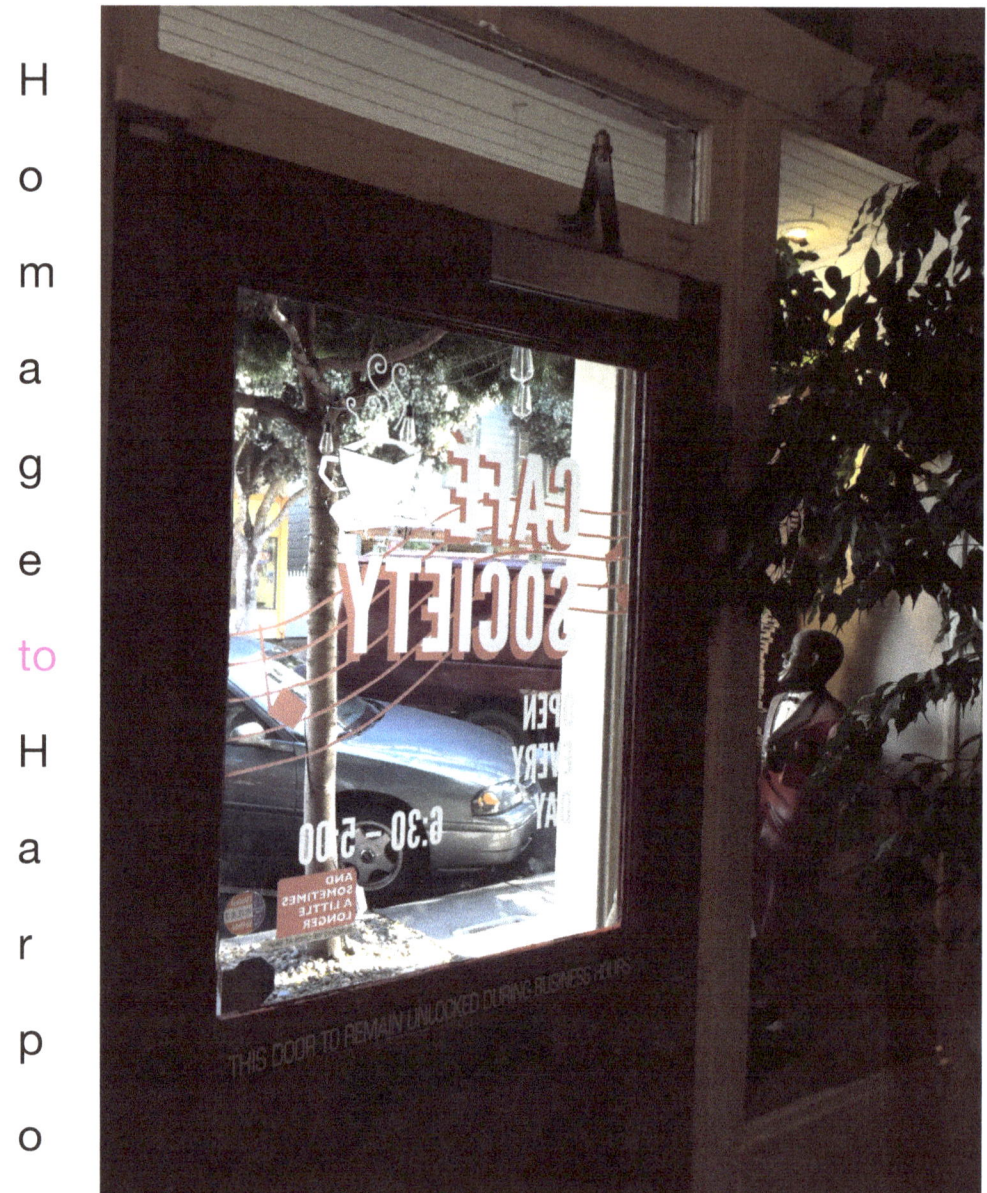

from Dusseldorf to Half Moon Bay
 the Mensch has come a long long way…

Birds Stop By

you and I
 can't go by
 we're flying high
 on Main Street
 upbeat sigh
 ain't no lie
 birds stop by
 at this bay beat

 on Friday night they're all plucking keys
 filling space with their harmonies
 breaking free of all the vagaries
 going deep into those memories
 bah bah do bah bah do bah da

 Let's take a break from the daily news
 the acrimonious sour views
 a place to blow away our downward blues
you know damn well we've paid our dues
 ya bah da bah da do bah da

you and I
can't go by
we're flying high
on Main Street
upbeat sigh
ain't no lie
birds stop by
at Harpo's retreat

that east side village has nothing on this
way back sounds that do not miss
brought out here with a soulful kiss
to take us into that crazy bliss
 bah bah do bah bah do bah da

the saxophone's blowing out the door
a hundred toes tapping on the floor
everyone here really knows the score
they're all up jumping and wanting more
 ya bah da bah da do bah da

you and I
 can't go by
 we're flying high
 on Main Street
 upbeat sigh
 ain't no lie
 birds stop by
 at this Bay beat beat beat

Friday night

Friday night Friday night
got everything to do with living right
Friday night aww Friday night
Now I've got you in my sight

See you coming sweet and slow
See you moving with the flow

Friday night Friday night
They're blowing notes right out the door
Friday night aww Friday night
Feel it reaching to the core

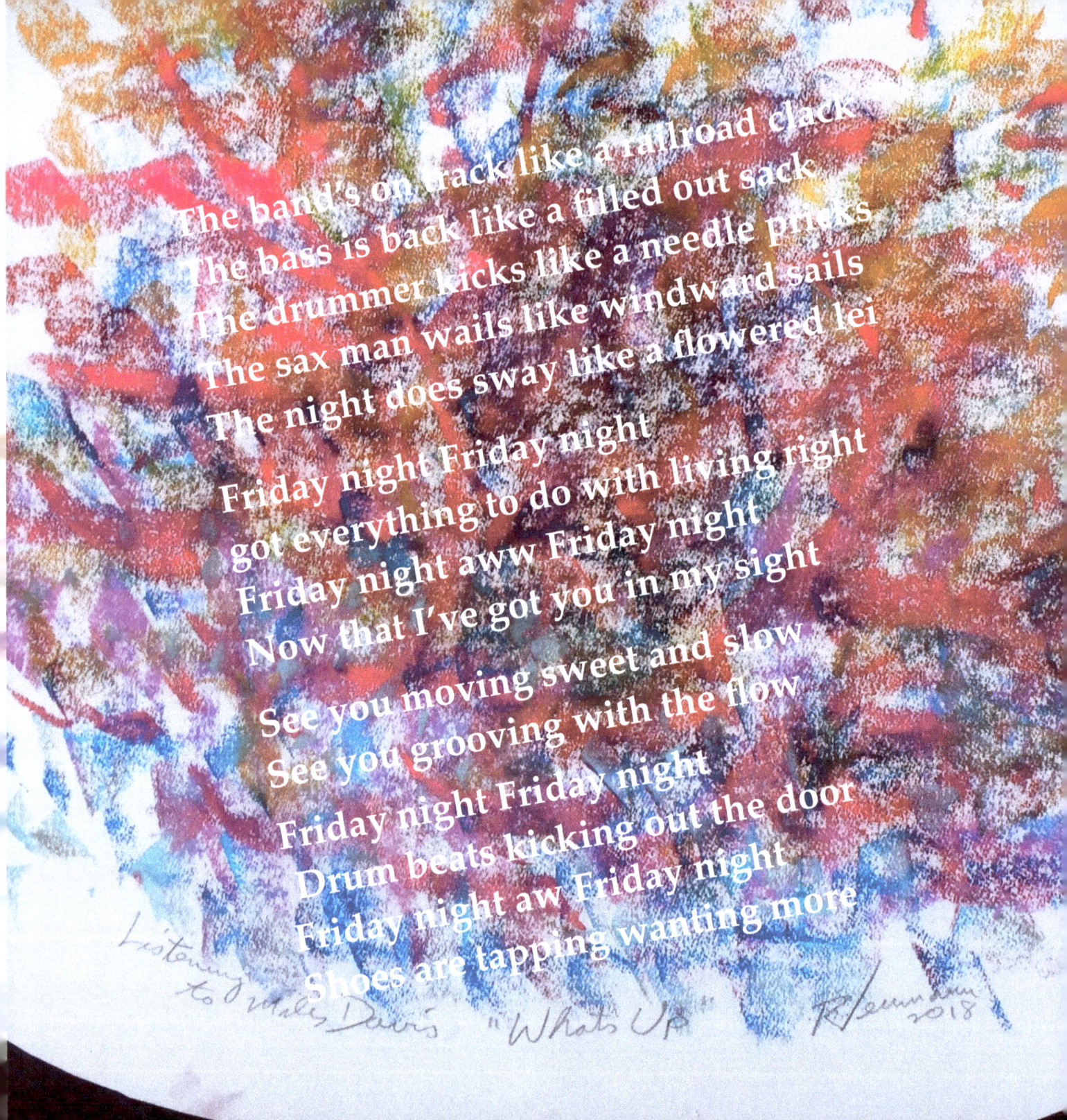

The band's on track like a railroad clack
The bass is back like a filled out sack
The drummer kicks like a needle pricks
The sax man wails like windward sails
The night does sway like a flowered lei

Friday night Friday night
got everything to do with living right
Friday night aww Friday night
Now that I've got you in my sight

See you moving sweet and slow
See you grooving with the flow

Friday night Friday night
Drum beats kicking out the door
Friday night aw Friday night
Shoes are tapping wanting more

The guys are hopping like popcorn popping
The gals are swinging like pizza flinging
The rap is beat like like a dog in heat
The scene is wild like eyes beguiled
The night's waiting like a numbered painting

Friday night Friday night

got everything to do with your smile

Friday night aww Friday night
Let's linger in this mood a while

Now we're moving sweet and slow
Yea we're grooving and ready to go

Friday night Friday night
got everything to do with living right
Friday night aww Friday night
Now we're swinging baby outta sight

Latin rhythms
And a flute is blowing
High dee high and crowing
Place is ripe and overflowing
Word got out
No need to shout
Let the sound
Come around
That's what it's
all about
No need to question
No need to doubt

Latin rhythms
And a sax is wailing
High dee low and scaling
Place is up and hailing
Word got out
No need to shout
Fill the boat
Still afloat
That's what it's
all about
No need to question
No need to shout

Bah da da da da da da
Oooh la la la la la lal la la
Señorita so sweet
Bah da da da da da da
Oooh la la la la la la la la
Hombre so sauve

Latin Rhythms

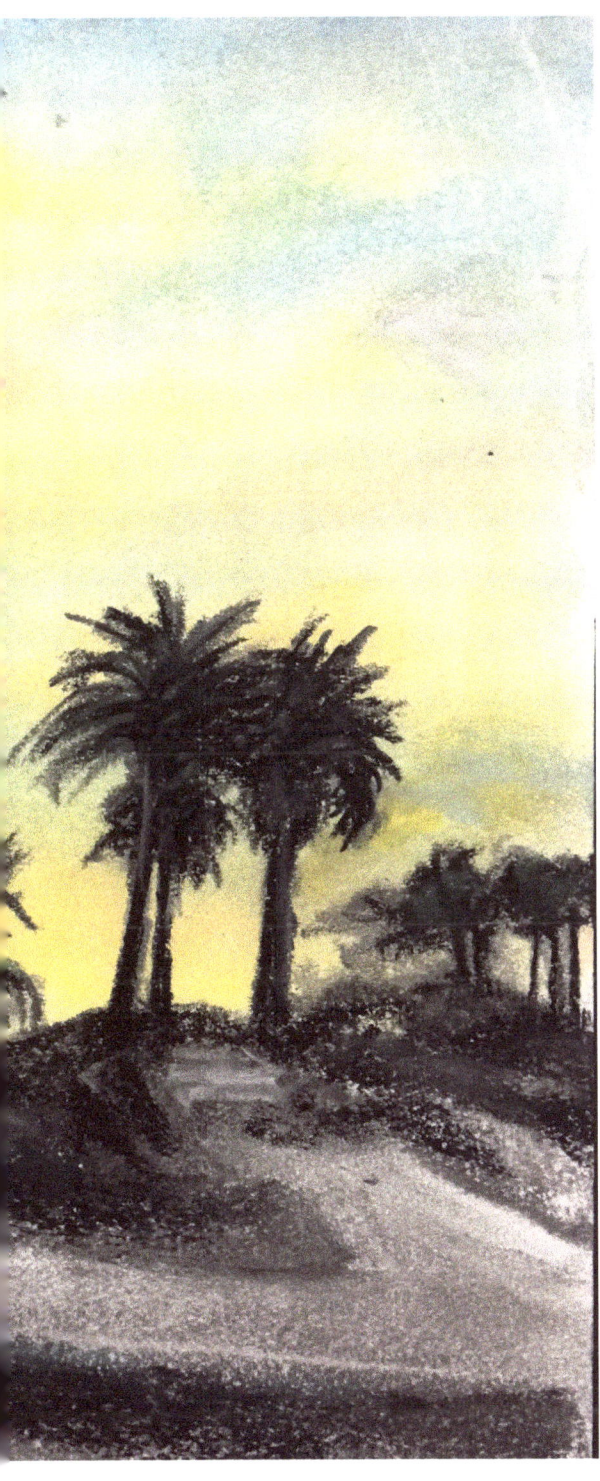

Latin rhythms
And a voice is crooning
Low dee soft and swooning
Mellow tuning
Word got out
No need to shout
Open the door
Let it pour
That's what t's
all about
No need to question
No need to doubt

Latin rhythms
And a Friday night treat
High dee high and sweet
When Brazil and the half moon meet
Word got out
No need to shout
Sway and play
Dance away
That's what it's
all about
No need to question
No need to doubt

Bah da da da da da da
Oooh la la la la la lal la la
Señorita so sweet
Bah da da da da da da
Oooh la la la la la la la la
Hombre so sauve

Black Notes Movement
Or Abram's Treat (Where Friday night jazz and locals meet)

the tempo is mellow
a slow heart beat
one two three trick
and treat
soft brush scritching
Got us itching
In our seat
 We're ready ready ready ready ready to meet
 Keyboard climbing
 Fingers gliding
 Up and down
 In this very very very very laid back town

paintings hung around the room
Static movements all in place
black and white notes on the staffs
Ancient mystic looking graphs
Imagined sound
Lost and found
 While below the combo clicks
 Plucking bass
 electric mix
 Drummer cracks
 On upbeat sticks
 Letting us
 Get our kick

Just settle in mensch
Grab a good bench
one two three trick
and treat
snare drum ringing
Notes are singing
low and high
with a hidey hidey hidey hidey fit to die
 cymbal smacking
 bass keeps cracking
 on those strings
 with a dizzy dizzy dizzy dizzy
 flick and fling

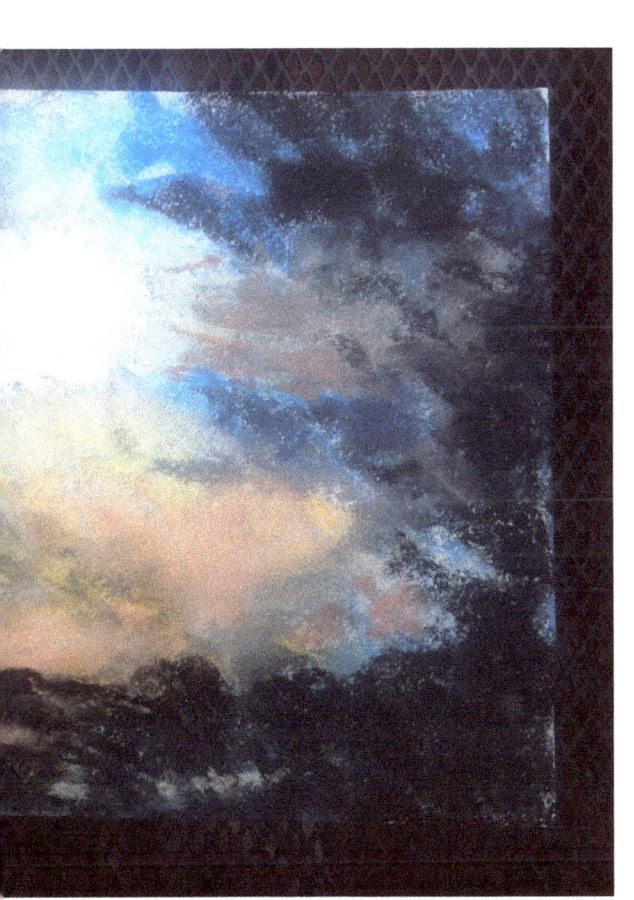

Well he's swaying in a knitted hat
Always knowing where he's at
Roaming up and down that board
Jazzy sounds we can all afford
A knowing tune
An ancient rune
This combos got it oh so tight
Shuffle and snare
Beats alright
ahh they wax
in the cafe light
Letting us
Fly at night

 stand up base run
 won't be undone
 one two three trick
 and treat
 chords are smiling
 there's no denying
They make my day
 in a zany zany zany zany swinging way
 Door is open
 Sax man hopen
 Blows it all out
 With a wailing wailing wailing wailing way to shout

here's the sound of shoes a tapping
Even someone's finger snapping
Each cat makes a solo run
Call and response has just begun
Keyboard's on
They're real gone
In this magic real time land
Cymbals beat
Keys repeat
While the bass
Takes a stand
Letting us
Clap our hands

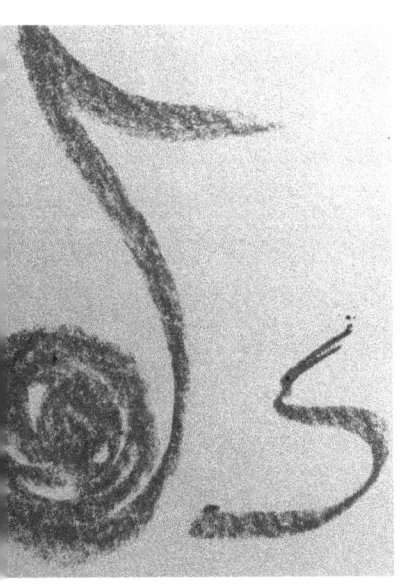

Candles flicker in the evening glow
The combo's put on quite a show
Wine was flowing and beans were pressed
A few hours away from worldly stress
Musician's named
Just short of fame
They finally take their well earned flight
Bodies move
Still in the groove
Let us go
Into the night
between the hanging moon
between the hanging moon
between the hanging moon

And the morning light

Let the sky blow in
 Let the waves rise fall and rise
 Let the jazz riffs fly

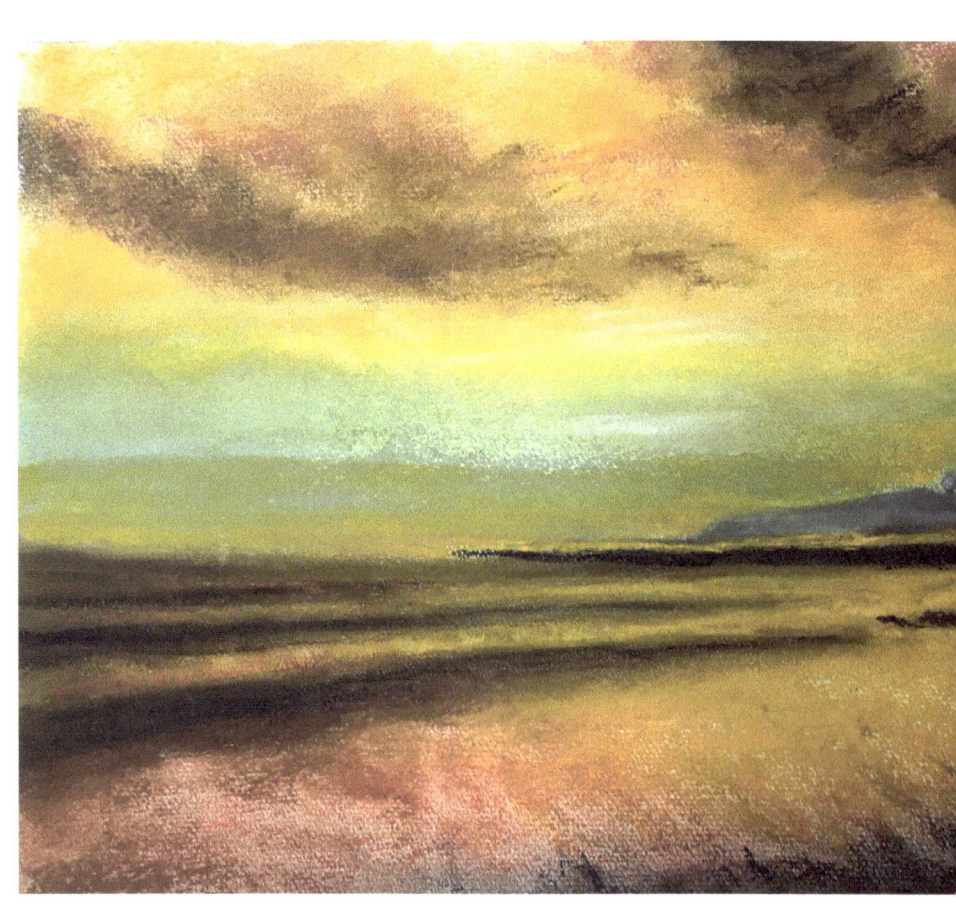

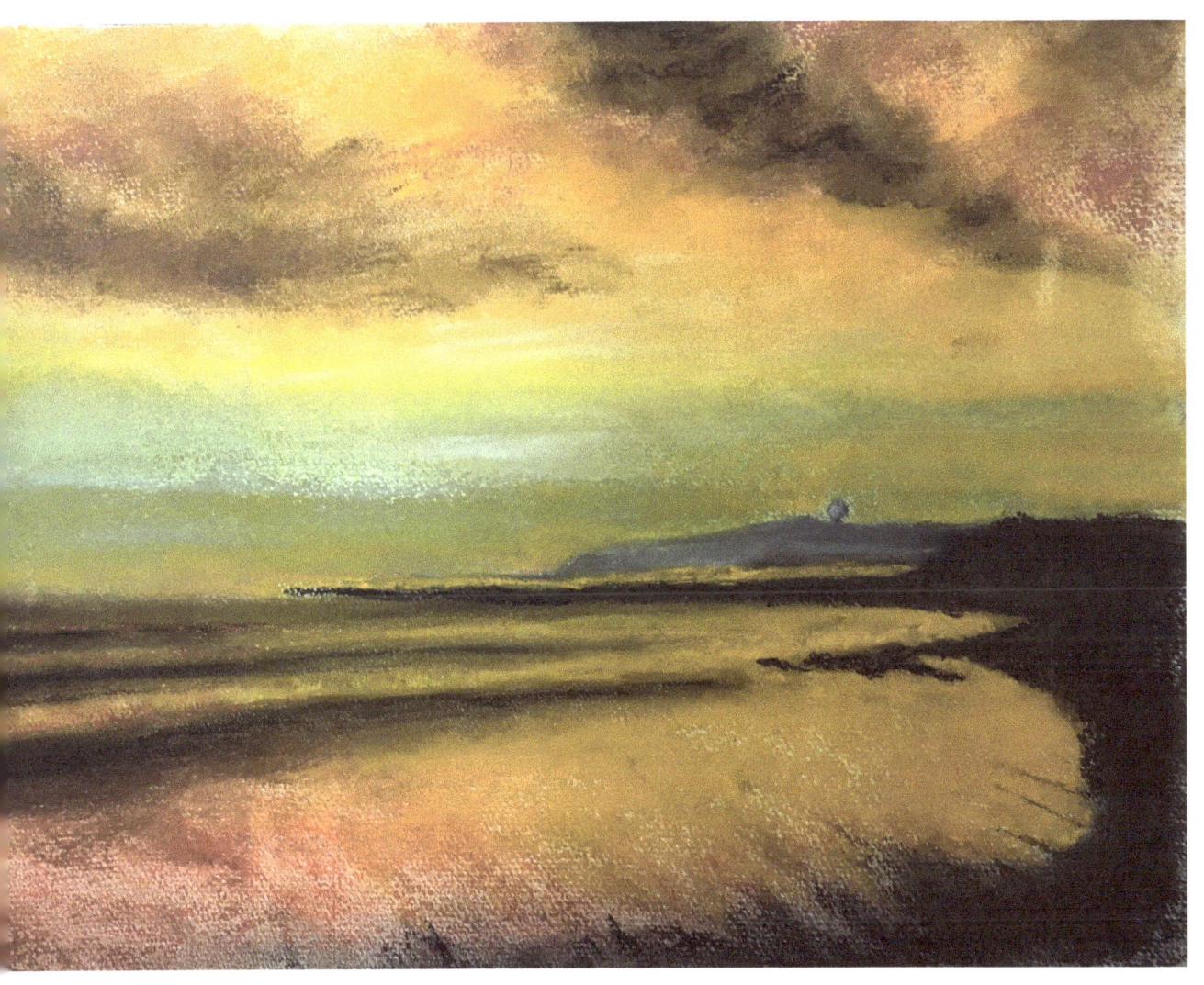

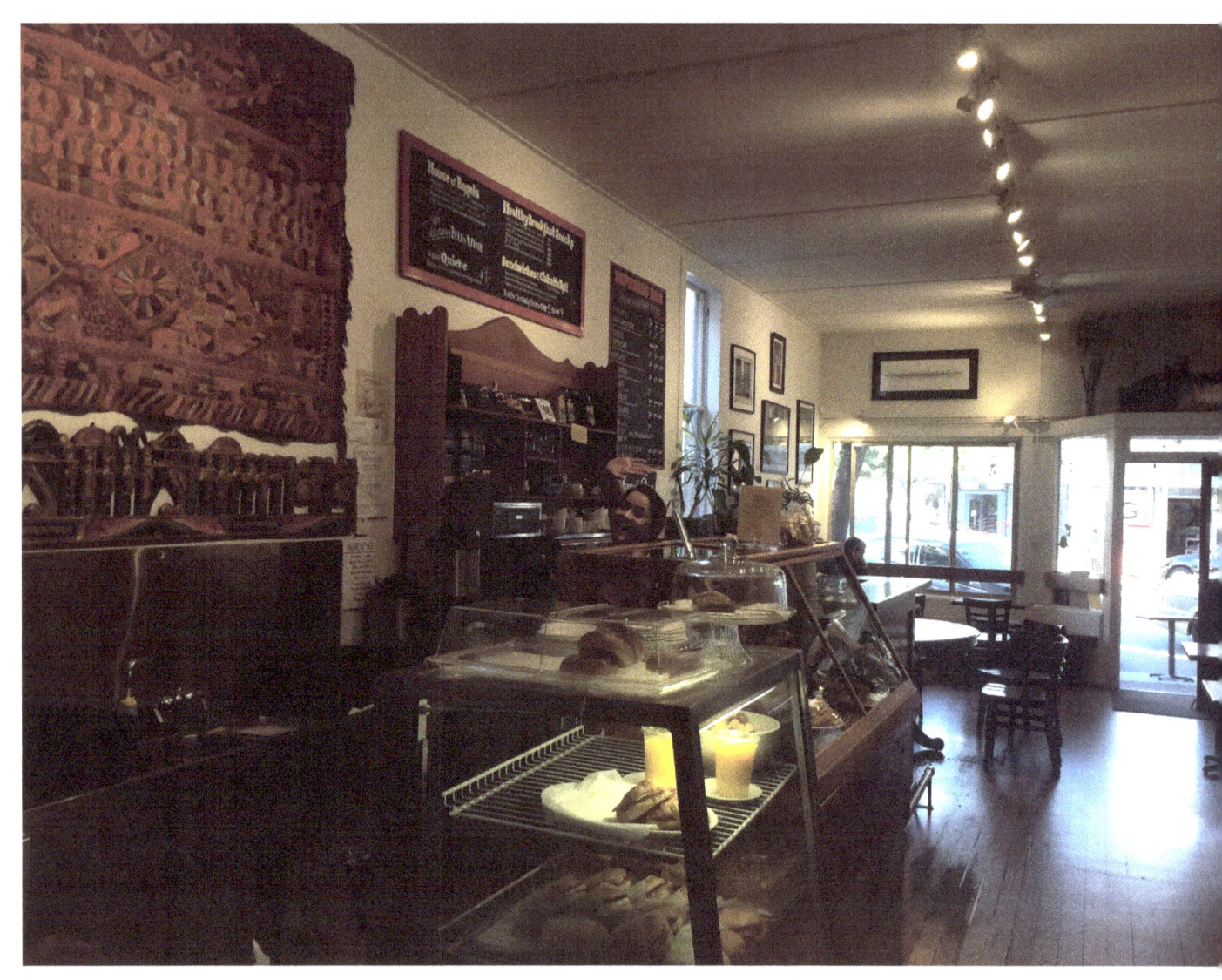

and a grateful thank you to all the

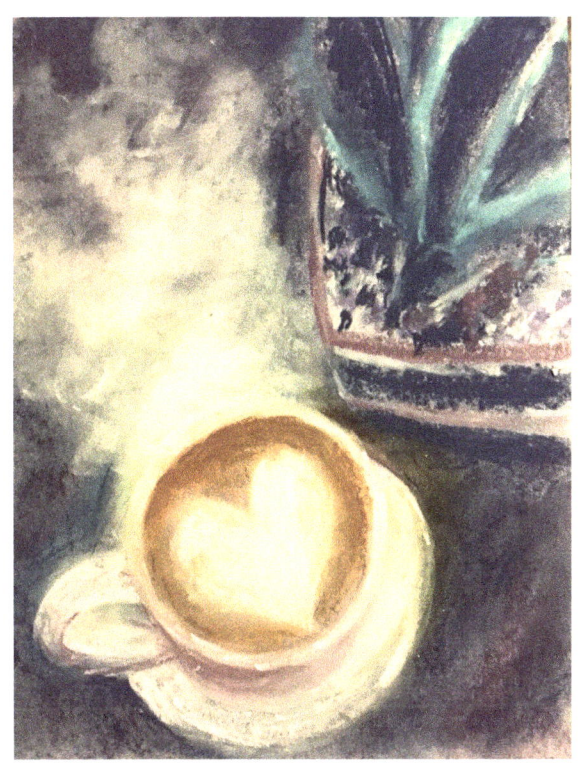

baristas

and caretaker

Rachid

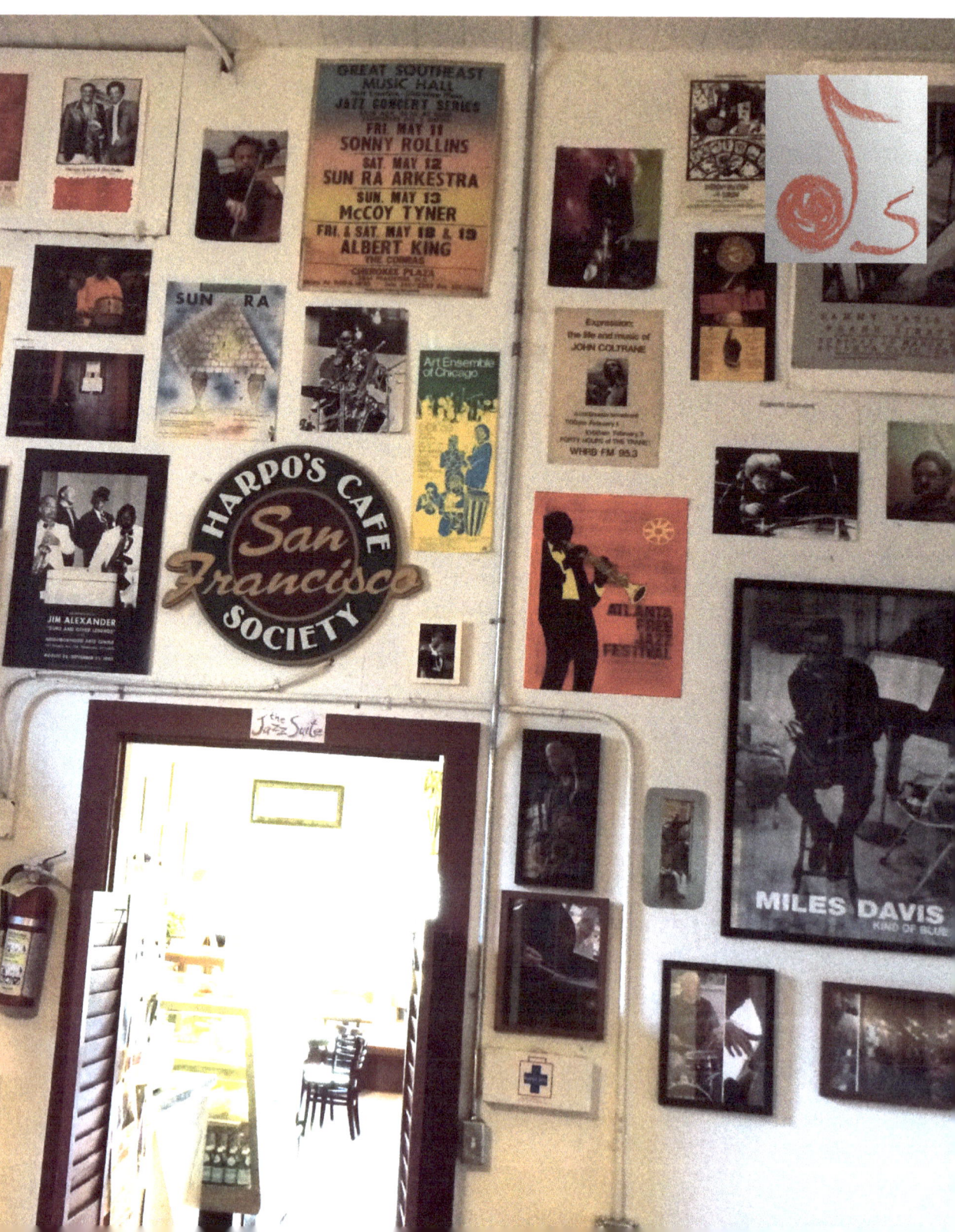

JAZZ SUITE

a back room
look through the door that says restroom
a classy looking man
 holds a finger to his lips
consider this moment
look around
all the images of this pantheon displayed
 in random organization
 caught in stillness
in shadow and light
some known outright
some playing once upon a cool night
some gone leaving notes behind
some still playing somewhere
in the corner of some late night place
 in Harlem
in St. Louis
in the memories of the Western Edition
 and the Keystone Corner where poets
 rhymed and riffed with the sounds that floated
 into a North Beach night
in the legacy of the Bach Dancing and Dynamite Society

Sunday afternoons
in here in a corner spot by the front window
of the Cafe Society
 usual tables are moved for a drummer
 a piano a stand up bass a guitar
 an occasional walk in sax and more

but in the back room
the players are caught in a static moment
as listeners walk through
imagining what the world once heard
from Miles Ornette

the suite is in transition
like a song that a trio starts with
 being played with
 over the chord structure of something familiar

the plates and glassware are piled high
still seen a piano tucked into the shelves
waiting for Brubeck to come back
or Marty to tackle the keys
 a phonograph is not plugged in
 albums of all night recordings
 sit next to it also waiting for someone
 who can't wait
the reminders are all around
hovering
in this sweet suite
of the gods
and their haunting everlasting
sounds

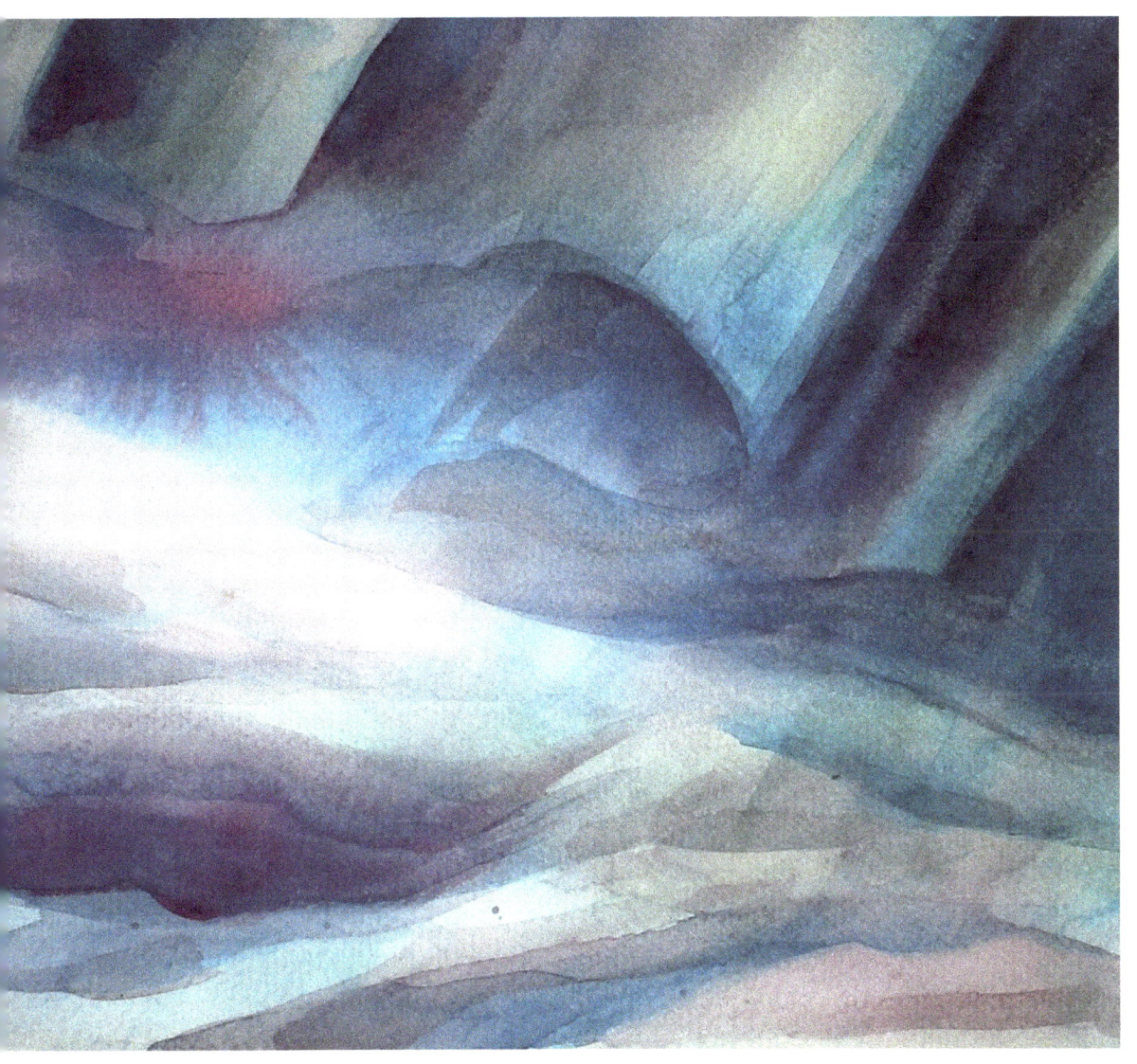

Let the good times come

they take their turns
around a melody
the bass keeps time
with piano keys

the sax man wails
occupies the room
lights up the crowd
like a full out moon

let the good times come
let the good times come
let the good times come
Let them happen soon

the drummer kicks
with his magic sticks
there's no retreat
when cultures meet

from a hollow log
to a shaman's fix
we're all part
of a mythic mix

let the whole world come
let the whole world come
let the whole world come
Lets get our kicks

counter rhythms
and a solid beat
the wine is flowing
and the tea is sweet

the bass man plucks
those strung out strings
going deeper than
our discord brings

let the good times come
let the good times come
let the good times come
mend our broken wings

the sound is heard
up down the street
Harpo's cafe
is the place to meet

the piano player
now skips and climbs
bridging over
divisive time

let the good times come
let the good times come
let the good times come
and let them shine

she's on the mike
feeling the heat
her voice begins
down in her feet

the talking stops
the hearts respond
the time is like
the break of dawn

let the sweet bird sing
let the sweet bird sing
let the sweet bird sing
til the bells all ring

and let the good times come
make some joyful noise
let the good times come
and let them happen here

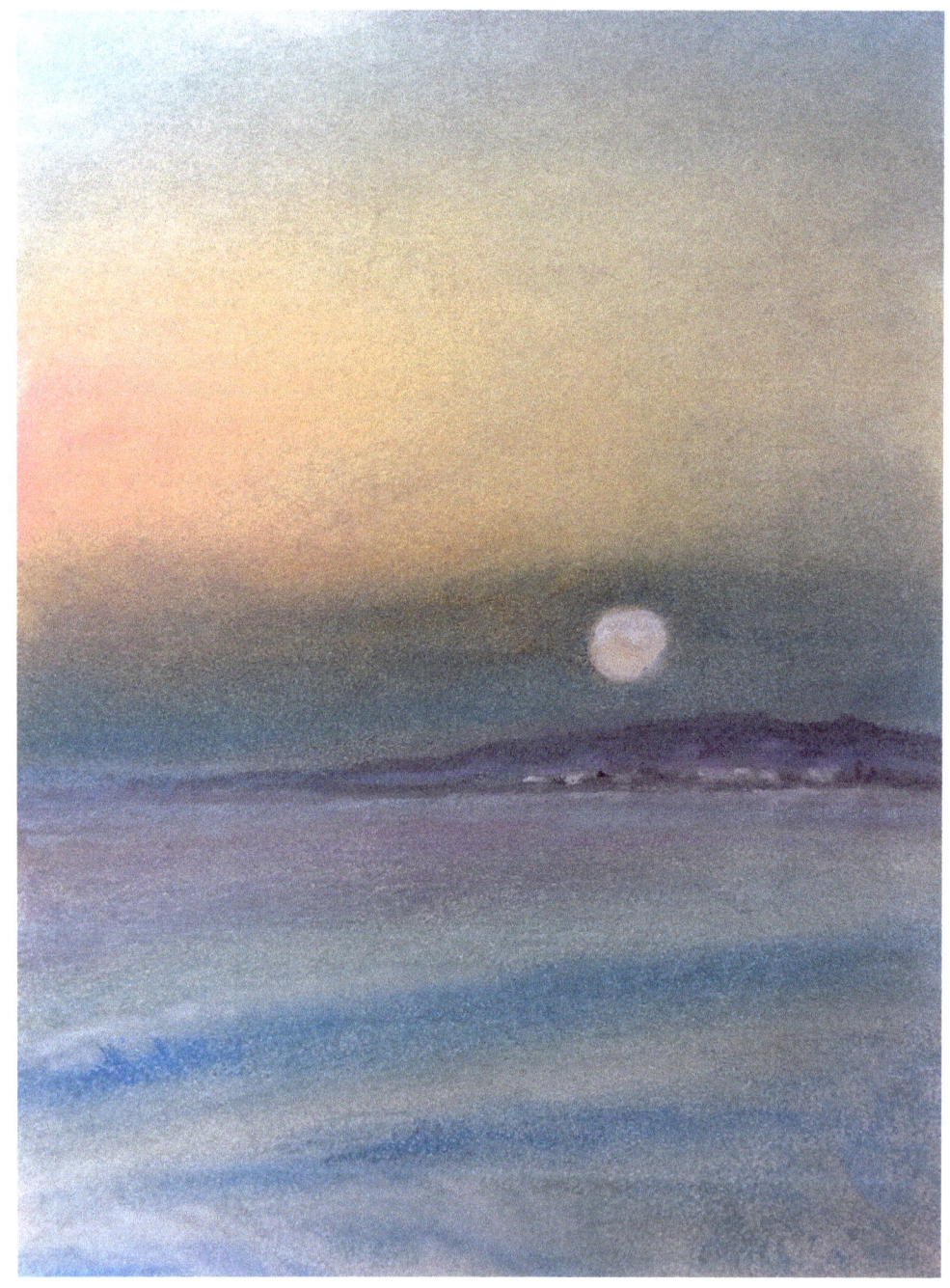

Mellow so mellow
Like wavering jello
Up and down the neck
Fingers pressing
Between each fret
Drummer breaks in
Snares are trembling
Cymbal minded
Beat decided
While I get my kicks
Off the drummer's sticks
I remember that old route 66
Baghdad Cafe has not gone away
If you're heading south
It's still got some sway

 Something about that stand up bass
 Plucking fills that curved out case
 Sending vibes around the room
 Taking off through cloud and gloom

After all the sudden rain
We begin to ease the lingering pain
Of what is lost and what is gained
While ocean air is blowing in
No one to blame no one to name
Ahh the combo overwhelms the din

 Letting notes rise and take a fall
While throbbing strings
Grab us by the unknown all

 The trio weaves the tapestry
 remembered notes remembered songs
 Embellished and elaborated
 Amplified and exaggerated

 Blowing them all out
 Tap and shout
 Taking a solo
 Feeling the mojo
 That's what it's all about

notes on

Songs
Birds Stop By (for Marty and band)
Friday night
Let the good times come
These songs have a rudimentary chord structure
and just need some of that jazzy work out and solo break out.
Poems
Latin rhythms
Black notes movement (for Steve and band)
Jazz suite
Jazz night
These are poems written while trying to do the impossible
- translating Friday night happenings into words.

*Dedicated to all the musicians
who have graced us with their sounds on Friday nights...
If I have missed someone please know that your music
is still ringing in the cafe...*

Steve Abrams Trio

Marty Williams and Friends

Alan Hightman Trio

Brian Andres Trio Latino
Christman Tumalan
Aaron Germaine

Julian Kucera Trio

Casulo Latin Jazz

Zeitgeist Quartet

Cypress Jazz Quartet

Creator of this small book of appreciation…

Rainer Neumann

Other Works

Exhibit books
from Pigeon Point to Point Reyes
pastel drawings and haikus
Homeland Serenity
pastel images and haikus
from Half Moon Bay

Other Books
Masama
Labyrinth a mythic journey
Goodbye Bolinas we'll see you again
On the Wings of a Swan

Path and Goal
poetry by Alfred Neumann
I am always with you
a journal by Marianne Neumann
both books translated by the author

Available through:
lulu.com/spotlight/rneumann
For further inquiries:
onhighwayone@gmail.com

www.ingramcontent.com/pod-product-compliance
Lightning Source LLC
Chambersburg PA
CBHW041922180526
45172CB00013B/1357